Excerpted from *One Zentangle a Day: A 6-Week
Course in Creative Drawing for Relaxation, Inspiration,
and Fun* by Beckah Krahula, Quarry Books 2012,
ISBN: 978-1-59253-811-9

The Zentangle® art form and method was created by Rick
Roberts and Maria Thomas. Zentangle materials and teaching
tools are copyrighted. "Zentangle" is a registered trademark of
Zentangle, Inc. Learn more at zentangle.com

All artwork by Beckah Krahula with the exception of the
following: Angie Vangalis, box back, left; book jacket back,
bottom; 29 (right); 31 (right)

11
ISBN: 978-1-59253-889-8
Design: Debbie Berne Design

Printed in China

WHAT IS
Tangle Art?

Tangle Art is inspired by the Zentangle® method of creating abstract works of art. A tangle art drawing is created from a collection of patterns not meant to represent anything. It is created on a 3½ x 3½-inch (8.9 x 8.9 cm) piece of paper, called a "tile." This size allows for a work of art that can be completed in a relatively short time. The process uses a meditative art form, a pen, and pencil. If you do not like the look of a stroke you have made, it then becomes only an opportunity to create a new tangle, or transform it using an old trusty pattern.

A tangle art tile is meant to be a surprise that unfolds before the creator's eyes. The process of drawing tangles is unplanned and intuitive. There are no expectations or planned goals to worry about attaining. With no plan to follow, there is nothing to detract from the stroke being drawn. The lack of planning and the tangles allow the unexpected to occur.

The process of creating tangle art teaches us to become comfortable letting our instincts be in control, so it does not matter that you do not know what you are doing next. Practicing meditative drawing teaches you to look at your work from every angle, which allows you to acknowledge all the possibilities of the piece and the opportunity to make decisions as the artwork evolves. Being locked into planned goals can cause the loss of opportunity for the piece to flow naturally together. Following a plan can often leave the artwork feeling stiff, rigid, or lacking in continuity. Once you grasp the concept of meditative drawing, you can easily expand upon it as you travel on your creative journey.

One of the wonderful things about meditative drawing is that, like life, a tangle is always a work in progress. There is always another stroke that can be deliberately made, a new pattern to learn or invent to cover or transform an area you are not happy with. Just as in life, we often learn the most from transforming an area we do not like.

Remember, there is always the next tile to be created, and each one is an opportunity to learn. Just as it is impossible to judge a life's work that is ongoing, it is impossible to judge a tile half-tangled. Just relax, focus, and allow your unplanned abstract drawing to take shape. Leave all expectations, criticisms, and comparisons behind each day when it is time to tangle. Each tangle will be unique and different. Some will be prettier, others stylish, dynamic, animated, or a feast of contrasting tones for the eye. Each will have strengths and weaknesses, and together they will create the mosaic of your creative journey. The important part is to tangle every day.

Supplies

This kit contains 2 felt-tipped pens, size 01 and size 005, and 20 blank drawing tiles. In addition, there is a pencil for practicing your tangles on the blank pages at the back of this book. Your pens and tiles are all you will need to complete the exercises that are included. If you get hooked on Tangle Art, and want to continue with it, you can learn more in the full book from which this material was adapted: *One Zentangle a Day* (Quarry Books, 2012) by Beckah Krahula, available online and in bookstores.

Getting Started

Tangle art can really be done anywhere, as long as you can hold your tile, pencil, and pen. I always have a mini kit in my purse in case I feel inspired, need to alter my mood or stress level, or want to alleviate boredom. Tangling on the run is a great idea for getting through the events of daily life while bringing a little beauty to each day, but it's not the ideal way in which to learn a meditative art form.

To get the most out of your tangle art journey, create a time and space where you can spend thirty minutes creating your daily tangles. This does not require setting up a studio. Find a space you enjoy being in. Make sure you have good lighting, a table or hard surface to work on, and a place to sit. The area should be free of interruption. Background music can be great for drowning out irregular interruptive noise. Choose something that will allow you to relax but stay focused and not put you to sleep.

The art evolves from a border, string, and tangles that are drawn on the tile.

To get all the benefits from meditative drawing, it is important to follow the process. Simple steps naturally progress from one to the other with no need for planning. First a pencil is used to draw a dot in each corner. The dots are connected by a line to create a border. Next the string is created with the pencil. A string is an abstract shape that divides the area inside the border. These divisions are filled with tangles that are drawn with a felt-tip pen. Tangle patterns are made from a series of repetitive, easy-to-create, deliberate pen strokes. The process is very rhythmic, centering, and relaxing. By following the same steps each time, a ritual is created. The ritual becomes more familiar, comforting, and relaxing with use. Benefits such as developing new skills while enhancing old ones, stimulating creativity, purposefully redirecting your mind and thoughts, improving focus, calming and centering the mind, and releasing stress become easier to achieve.

Examples of borders and strings.

The nine steps are as follows:

1. Find a relaxing time to draw.

2. Assemble your kit materials.

3. With your pencil, create a light dot about ¼-inch (6.4 mm) in from each of the corners of the tile. No need to measure; just place them where it feels right.

4. Using the pencil, draw a line from dot to dot creating a border. Don't worry about it being straight, because the eye finds curved lines more interesting.

5. Create a string. The string creates a division of areas in which to lay tangles. It is the creative map of your meditative drawing journey. The string can be any shape, size, or on any spot inside the square and doesn't have to be a continuous line. Not every section of the string has to be filled with a tangle. If instinct tells you to leave an area blank, then follow your intuition. The string is meant to dissolve away into the background of the finished drawing like an invisible border or edge. Never draw the string in ink because then it creates a border that becomes the focus, much like the effect found in a coloring book. It is no longer a suggestion; the string is now a rigid border that limits the options for placing tangles. When the string

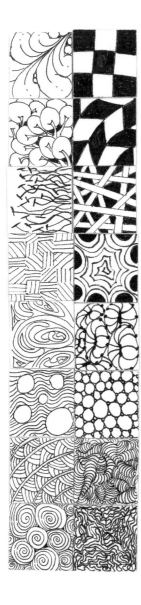

is in pencil, experienced tanglers can study the piece and imagine what the string looked like when drawn.

6. Pick up your felt-tip 01 pen. Turn your tile and examine the pattern that the string makes from each angle. Hold it out at arm's length so you also see the composition from a distance. Following your first impulse, start filling in each section of the string with the tangles learned that day. Do not overthink your decisions, and don't hurry. Be deliberate and focus on each stroke. Turn your tile as you work to make it easier to create a design.

7. With your pencil, shade your tangles. In the beginning, we will shade the tangles by using the side of the pencil around the edges of each tangle then smudging it with our finger. This type of shading should be darker toward the edges, lightening as it comes into the tangle to control the amount of gray used. Shading is not effective if the whole piece is gray.

8. Once again, turn your tile and view it from each angle. Decide how you wish the piece to be viewed. Using the felt-tip pen, place your initials on the front of the tile. Turn the tile over and sign your name and date the piece. You may add any comments here, like where you were, with whom, or if it is a particular event that day that this drawing honors.

9. Appreciate and admire your piece, not just up close but also from 3 to 4 feet (0.9 to 1.2 m) away. It is amazing how the piece changes from a distance.

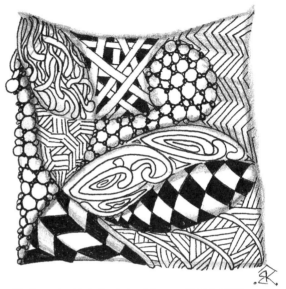

Shading only adds to the design if there are tonal contrasts between shaded and nonshaded areas.

GETTING ACQUAINTED WITH YOUR TOOLS

MATERIALS

felt-tip 01 pen
pencil
sketchbook
tile

The first project is designed to give you the opportunity to become acquainted with the use and feel of the felt-tip pen while creating the mark that identifies a completed tile as your own. When a piece of tangle art has been completed, the creator first signs the front of the piece with his or her initials in ink, which becomes the signature on the front of the tile. Small, uniquely stylized, and individual, the signature represents the unique artist. Each tangle artist is encouraged to spend time creating this signature. Turn to the first unused page in your sketchbook and practice using the felt 01 pen as you create a stylized signature from your initials. Remember to use light hand pressure when using the felt-tip pens, as heavy pressure will destroy the tip of the pen. You will have better control if you pull the pen toward yourself as you create the pattern strokes.

Have fun with this exercise—be spontaneous and experiment with the types of marks the pen can make.

DAILY TANGLE PATTERNS

Try these three tangles. The Static tangle is an easy tangle to start with, but try to keep the spacing between the lines even. For the Tipple, do not worry about creating the circles all the same size. To produce nice round orbs, slow down and focus on the stroke. When creating the Crescent Moon, even spacing on the half-moons helps create a feeling of balance.

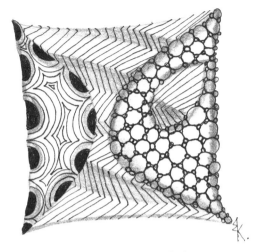

Sample using Crescent Moon, Tipple, and Static

STATIC	TIPPLE	CRESCENT MOON

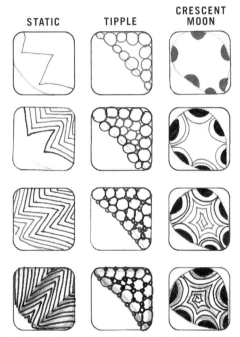

Practice these tangles in your sketchbook.

PATTERN AS TONAL VALUE

MATERIALS

felt-tip 01 pen
pencil
sketchbook
tile

Each tangle has a tonal value. Tangle patterns can be mixed together on a tile to create a variety of interesting values. Values, for our purposes, are the shades of black, white, and gray that each tangle contains. The intensity or amount of light or dark a value has is referred to as *tone*. Tonal values are created or changed by altering the amount of white space versus dark space in a tangle. Placing the pattern closer together along the edges creates a darker value on the edge. Opening the center of the same pattern adds to the illusion of form and helps create depth. The altering of a tangle creates the illusion of different tones on a tile. It creates form, shape, highlights and/or shadows, and interest, and helps to move the eye through the piece.

This is a great technique for adding form and creating shape.

Sample of Knights Bridge

DAILY TANGLES

Try these three tangles. Knights Bridge tangle can be drawn as both a square checkerboard or a diamond-shape checkerboard. Nekton and Fescu tangles can be made open and airy by keeping the spacing wider between the lines in the pattern. They can be made denser and appear darker by placing the lines closer together. Practice these patterns in your sketchbook until they feel familiar.

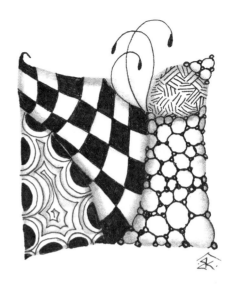

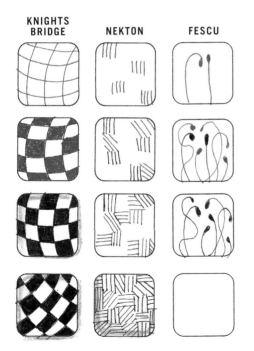

KNIGHTS BRIDGE **NEKTON** **FESCU**

Create a tile with the three new patterns and any of the patterns previously learned.

THE STRING

The string is the foundation of our drawing, but it is just a suggestion. Use it when and where you want to. The string is the only part of creating a drawing that is spontaneous. There is no plan in spontaneity. If the body is relaxed, the pencil can move freely across the page to follow a whim or creative spark or to fill an empty area.

The sketchbook is a great place to practice creating strings. Turn to a new page in your sketchbook. Use a pencil to create four dots in a 2½-inch (6.4 cm) area. Connect the dots and draw a string. Fill the page with strings. Try creating curvy strings, straight and angular strings, and combining the two. Changing how you hold the pencil can also make a difference. Try several positions to find out what works best for you.

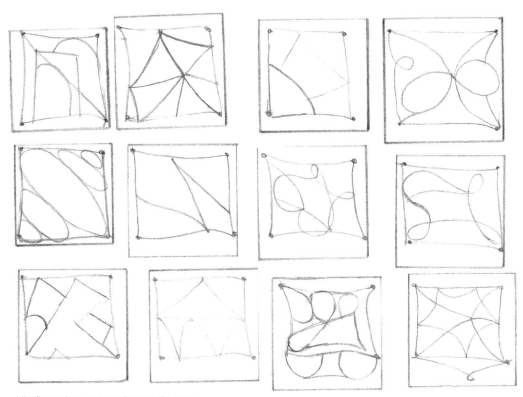

Like fingerprints, no two strings are the same.

OVERLAPPING DESIGNS TO CREATE DEPTH

MATERIALS

felt-tip 01 pen
pencil
sketchbook
tile

Some patterns naturally lend themselves to creating depth, especially when the pattern is overlapped and repeated until the area of the string is full. This gives the impression that the pattern is receding away. Refer to the diagram below. To create this effect, draw the tangle once. See box 1. Think of this pattern as now being opaque (i.e., nothing should show through it). Repeat the pattern, but lift the pen off the paper when you come to the first drawn pattern. Continue the pattern with the pen in the air until you reach the other side of the first pattern where the rest of the new pattern should appear. See box 2. Do not draw on top of the original pattern, or the new one created behind it. Consider the patterns in the front opaque, blocking out all beneath it. Repeat until the string area is full. See box 3.

1.
2.
3.

DAILY TANGLES

Try these three tangles. The patterns for the Poke Root, Festune, and Hollibaugh tangles become smaller as they recede, adding greater depth. Or, you can achieve a very organic look by keeping them all close to the same size. Practice these patterns in your sketchbook until you are familiar with them.

POKE ROOT **FESTUNE** **HOLLIBAUGH**

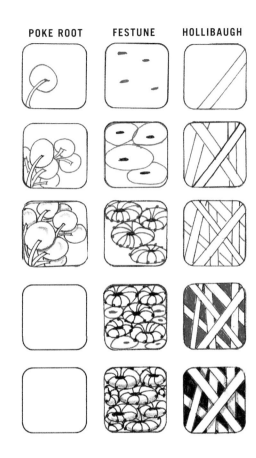

ORB OR HOLE, ONLY THE SHADING WILL TELL

MATERIALS
felt-tip 01 pen
pencil
sketchbook
tile

Even though our tangles are abstract pieces of art, shading is still a very important part of the art piece. Shading draws us in. It helps move the eye through the piece. Shading makes the dips, curves, edges, and angles in our artwork believable. It can be used to add atmosphere, weight, and tonal contrast, and it can make an unrecognizable world seem familiar and inviting. While shading, pick an area to use as the light source. If the light is coming from the upper-left area, the shadows will fall toward the lower-right sections of the patterns. If the light source is coming from the lower-left area, the shadow is cast toward the upper-right sections.

Create a sample tile on a clean page in your sketchbook using any three or four tangles. Select a direction for the light source for each sample and shade accordingly.

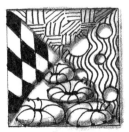
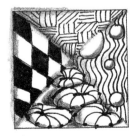

By picking a light source, shading becomes natural and there is no need for decisions.

DAILY TANGLES

Try these three tangles: Shattuck, Nipa, and Jonqual. Nipa is the first pattern we are learning in which you can treat the circle as a hole or an orb. Shattuck and Jonqual are angular patterns. For best results, focus on keeping the spacing even between the strokes on each of these patterns. Remember to turn your tile as you change angles while drawing patterns such as Shattuck so you can create your strokes more accurately and comfortably. Practice each of these patterns in your sketchbook until they feel familiar.

Create a tile that uses Shattuck, Nipa, and Jonqual.

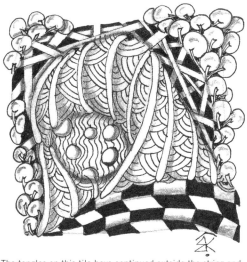

The tangles on this tile have continued outside the string and stopped at the border.

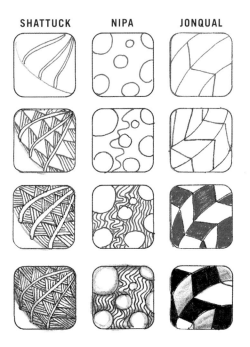

SHATTUCK	NIPA	JONQUAL

ADDING A SPARKLE

MATERIALS
felt-tip 01 pen
pencil
sketchbook
tile

A sparkle is a great description of a highlight and is another Tanglehancer. A sparkle is created when you leave a deliberate gap in a stroke while creating a tangle. As you are drawing out a tangle stroke, pause and lift your pen, leaving a slight gap in the stroke before placing the tip back on the paper and finishing the stroke. Creating highlights in a drawing in this manner is reminiscent of the highlights found in old ink drawings and engravings. Sparkles add light to your tangles, a small flicker to capture the eye and entice the viewer. Isochor and Printemps are two tangles that traditionally contain highlights. You can use a highlight in any tangle you choose, not just those traditionally containing them. Where the highlight is placed will affect where the shading is placed.

Try these two tangles. Printemps is a closed coil. Slow down when drawing this pattern so you can keep the area between the lines of the coil even, gradually tapering the space down to close the coil. While filling an area of a string with Printemps, the sparkle should always appear in the same place on each coil, and not every coil has or should have a sparkle. Just like the shadows, the highlight can be overused, and the contrast lost. A pattern drawn in the round, such as Printemps, has the shadow placed on the side of the coil without the sparkle. Drawn images are ink and graphite on flat paper, but adding highlights and shadows to the images gives the appearance of dimension and form. Isochor uses lines to bring volume to an area. Altering the direction of the lines in areas falling behind an area that also uses Isochor helps the eye take in all the line movement and creates depth.

Practice each of these patterns in your sketchbook until they feel familiar.

Create a tile that includes Isochor, Printemps, and any previously learned tangles you choose to use.

ISOCHOR PRINTEMPS

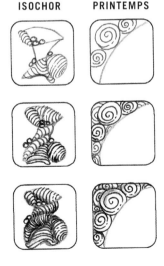

Treat a sparkle as a small light source. There should be no shadow inside the sparkle and a small area around it.

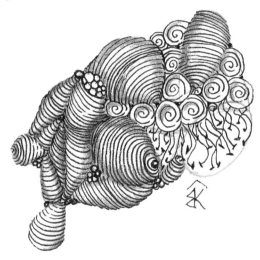

Sample using the Isochor and Printemps tangles

23

ONE-STROKE PATTERNS

MATERIALS

felt-tip 01 pen

pencil

sketchbook

tile

One of the prerequisites to a design becoming a tangle is that it be completed in a few strokes. Some are completed in one stroke, many in two. Mooka, for example, is a pattern made from start to finish without lifting the pen, thus one stroke. One-stroke patterns are very effective in relaxing into any meditative art form. Quick to learn and easy to remember, one-stroke patterns are quick to find their way onto many tanglers' favorites list.

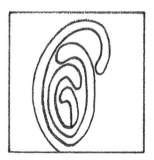 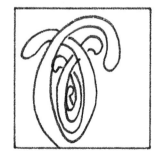

Mooka is fun, creative, and exemplifies a beautiful one-stroke pattern. From the start to finish of this pattern the pen never leaves the paper.

DAILY TANGLES

Try these three tangles. Amaze is a meandering tangle created from a meandering line that never crosses itself. The key to success when drawing Mooka is to slow down. Be deliberate in where you are moving the pen. Flux is one stroke repeated several times.

Practice each of the tangles in your sketchbook until they feel familiar.

Create a tile using Amaze, Mooka, and Flux tangles. Any of the other patterns previously learned may also be used.

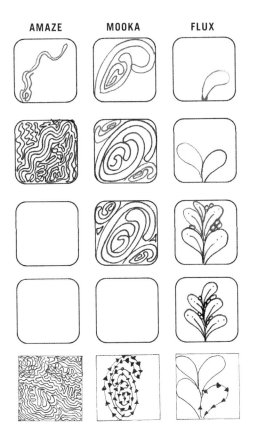

AMAZE **MOOKA** **FLUX**

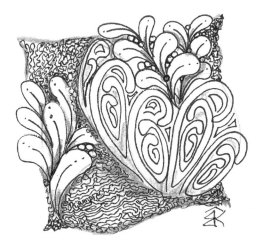

Amaze, being a denser pattern than the other two, creates a background for the lighter toned patterns of Mooka and Flux.

FROM FLAT TO 3-D IN TWENTY MINUTES

MATERIALS

felt-tip 01 pen
pencil
sketchbook
tile

Tonal ranges turn a flat line drawing into a dimensional shape. Graduating the shadows from dark to light gives shapes volume. If the light source is from above, the light is stronger at the top of the pattern, making the shadows there lighter than those at the base of the pattern. Start the shadow in the darkest area and lighten up as you move the shadow out. Do not shade the whole area gray. The shadow has changed in tone, not size.

Tonal ranges in the shadows should be close together and transcend softly.

DAILY TANGLES

Try these two tangles. Vega can create a border or be used to overlap itself with interesting textural results. Turn your tile often when drawing this pattern or any pattern that changes direction. This ensures your hand is at the correct angle to maintain control as you draw

each stroke. Much of the form of the second pattern, Purk, is established in its shape. The shading on the orbs of this tangle brings out the dimension.

Practice the new patterns in your sketchbook and when you feel familiar with them, create a tile using Vega, Purk, and any other tangle you choose.

VEGA **PURK**

Both patterns have strong silhouettes; Vega's is low key and Purk's is high key.

The larger size and darker shading of the middle Purk make it seem closer to the viewer.

LESSONS FROM A LANDSCAPE

MATERIALS
felt-tip 005 pen
felt-tip 01 pen
pencil
sketchbook
white tile

Although we are not actually going to draw a landscape, we are going to study how they are composed and then apply those principles to our tangled tiles. Compositional balance is achieved through a balancing act of shapes and their surfaces. Every shape has a visual weight. A shape's visual weight is affected by size, location, tonal value, background value, and emphasis on its contour. A familiar example of this is a landscape.

Landscapes create depth by gradually diminishing color and shapes as they recede into the horizon. The focal point is placed off center in the forefront of the composition, because it is closer to the viewer. It appears larger than the background shapes. Shading is darker and more defined on the focal point, while it fades with blurred edges that diminish on the background shapes. Physical weight anchors a composition and creates a visual balance with the light, airy atmosphere in the background. This effect can be used to create depth and compositional balance with the abstract shapes drawn on a tile.

Artists' value scale is much narrower than that found in nature.

DAILY TANGLES

Try these three tangles. Finery is a very light-toned tangle. For the best results, focus on spacing the lines evenly when drawing this pattern. Echoism moves the eye through a tile. I think of it as an abstract path leading the eye through the piece. Turn your tile when drawing the grid for Flukes.

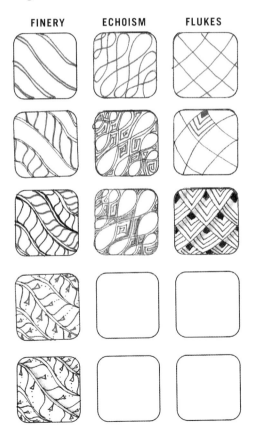

Practice Finery, Echoism, and Flukes in your sketchbook until they feel familiar. Create a tile using the three new patterns. Try creating depth by incorporating some of the techniques used to create a landscape drawing.

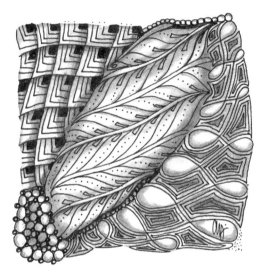

Angie added the pattern Tipple to today's pattern to help carry the eye through the tile.

AURAS & ROUNDING, TWO NEW TANGLEHANCERS

MATERIALS

felt-tip 01 pen

pencil

brush pens in black and gray

sketchbook

white tile

Today we will work with two Tanglehancers that can also affect your tonal values. Auras are created by carefully drawing within $\frac{1}{16}$ to $\frac{1}{8}$ inch (1.6 to 3.2 mm) around a tangle's edge. This creates a line that mimics the shape's edge. Keep the spacing even all the way around; drawing slowly helps. You can create auras in multiples and even place patterns in them. Auras are great for transcending from one tangle or tonal pattern to another.

Rounding on a tangle refers to darkening the crevices, nooks, and crannies. It is a little detail that gives a finished, classic look to the tangle. Rounding is done with a pen. It brings dimension, weight, and depth to a piece, and can be very useful in anchoring a pattern into the composition.

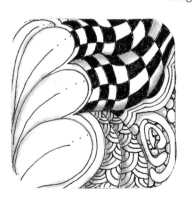

There are four auras around the Flux pattern. The first and second auras start the pattern Knights Bridge in them; the third and fourth were exaggerated and the pattern Shattuck was also added at the bottom. There are four auras under the Knights Bridge pattern.

DAILY TANGLES

Create today's tile using any tangles you choose.
Use an aura around at least one tangled pattern
and incorporate rounding on at least one pat-
tern. Last, challenge yourself to also use one
pattern you rarely use when you tangle. Add
any other patterns you would like to complete
your tile.

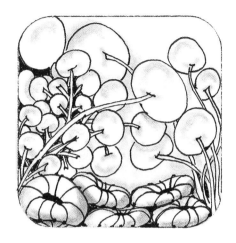

Rounding can help ground a pattern, create depth or a sense of
space, and increase eye movement on a tangled tile.

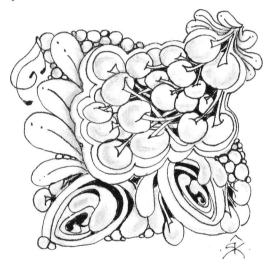

The auras help keep the patterns light and airy while the
rounding in Poke Root, Mooka, and Tipple help anchor the
composition.

BALANCING HARMONY & VARIETY

MATERIALS

felt-tip 01 pen

pencil

sketchbook

white tile

white ATC

The balance of harmony to variety in a composition creates eye movement. Harmony is created by a relationship between different areas on a composition that create a pleasing effect for the viewer. The relationship may be a similarity in shape, tonal value, size, or a combination of one or more. The common elements need not be identical, just close enough to visually link. If the pattern is too identical it will become boring and the viewer will lose interest. Some variety must exist in patterns to capture and keep the viewer's attention. Variety adds excitement and perks interest, but if overdone it can leave a piece feeling too busy, heavy, cluttered, and disjointed. Any one of these feelings can overwhelm viewers, causing their interest to move on.

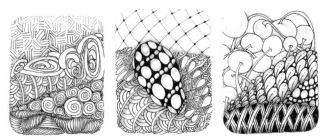

All three examples move the eye through the piece by decreasing tonal values as they recede.

DAILY TANGLES

Try these three tangles. Beelight resembles an earlier pattern we learned, Flukes, so it works well to create harmony in pieces. Chillon and Bales are two patterns that also share a visual likeness. Practice these three patterns in your sketchbook until they feel familiar.

BEELIGHT	CHILLON	BALES

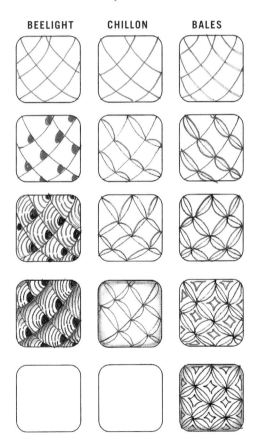

In both of these tiles it is the likeness of a few patterns that tie the composition together.

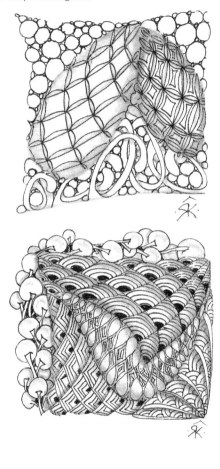

When you feel comfortable with the pattern, create a tangled tile using Chillon and Bales to create harmony in the composition. Choose patterns to use with Chillon and Bales that have enough tonal contrast to let them stand out.

Sketchbook